# THE FLETCHER FAMILY

# THE FLETCHER FAMILY

## A LIFETIME IN SURF

## DIBI FLETCHER

**RIZZOLI**
NEW YORK

New York · Paris · London · Milan

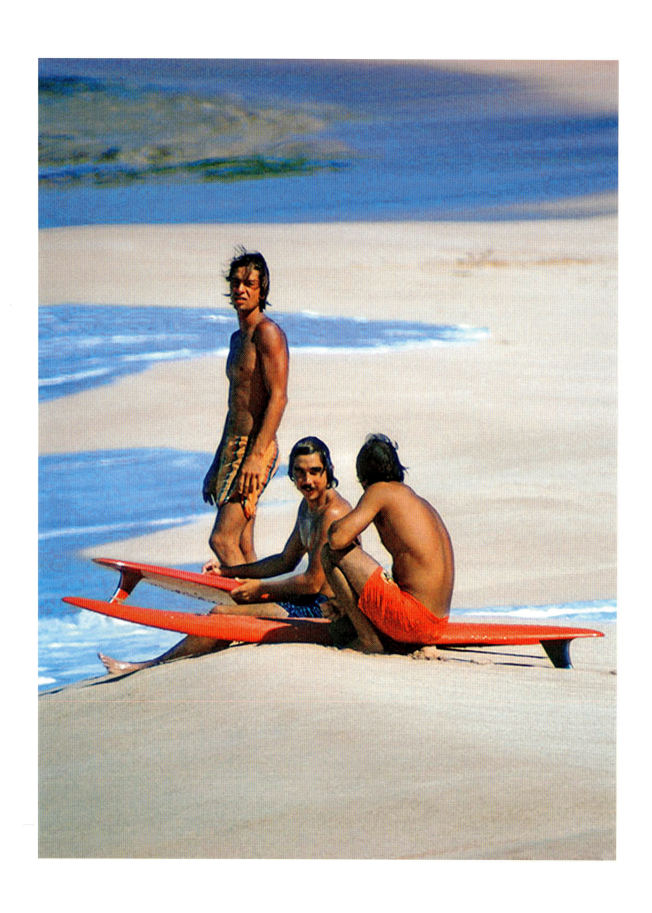

# A MODERNIST FAMILY

## GERRY LOPEZ

A MODERNIST FAMILY

HERBIE & DIBI & I HAVE BEEN FRIENDS FOR A LONG TIME, FIFTY YEARS OR MORE. THROUGH ALL THOSE DECADES, I'VE WATCHED CLOSELY, BEEN AMAZED, CONTINUALLY SURPRISED & EVEN SHOCKED BY HOW HE, HIS WIFE, BOTH THEIR SONS, CHRISTIAN & NATHAN & EVEN THEIR SON'S SONS, HAVE COLLECTIVELY BEEN OUT AHEAD ON JUST ABOUT EVERYTHING THAT I'VE EVER SEEN THEM DO. IT IS AS IF THEY ARE THE QUINTESSENTIAL DEFINITION OF AVANT-GARDE OR VANGUARDISM. WITHOUT A DOUBT, EACH OF THEM HAVE BEEN EXPERIMENTAL, RADICAL & UNORTHODOX WITH RESPECT TO CULTURE, ART, SOCIETY & ESPECIALLY SURFING... NONTRADITIONAL, AESTHETICALLY INNOVATIVE & INITIALLY UNACCEPTED BY PRO-FORMA STANDARDS. AS I WRITE THIS, I HAVE TO LAUGH & SHAKE MY HEAD AT HOW NORMAL THIS HAS ALWAYS BEEN FOR THE FLETCHER FAMILY, EVERY SINGLE ONE OF THEM IN THE MYRIAD ENDEAVORS THEY UNDERTAKE ON A REGULAR & ONGOING BASIS. I WON'T GO INTO LISTING THESE ACCOMPLISHMENTS BECAUSE THE PAGE ISN'T LONG ENOUGH BUT SUFFICE IT TO SAY, IT'S RAD!

ALOHA
Gerry Lopez

# A SHARED GIFT

## JULIAN SCHNABEL

I met Herbie Fletcher when I was sixteen years old. I had no idea what effect he would have on my life and how important it would be. It was through surfing—a path he would follow and guide his family on for life. I am a painter and have followed the practice of the artist, which in fact is no different than that of the surfer, who inscribes his or herself in the ocean—a bigger canvas could not be engaged, defining their humanity in the most personal way using themselves to draw their life lines through the massive fleeting freedom of that power. The power and majesty of the sea—Herbie shared that with me and with my family as well as his own. I love and respect the Fletchers and treasure the gift of camaraderie and surfing that we have together for what has turned out to be a lifetime.

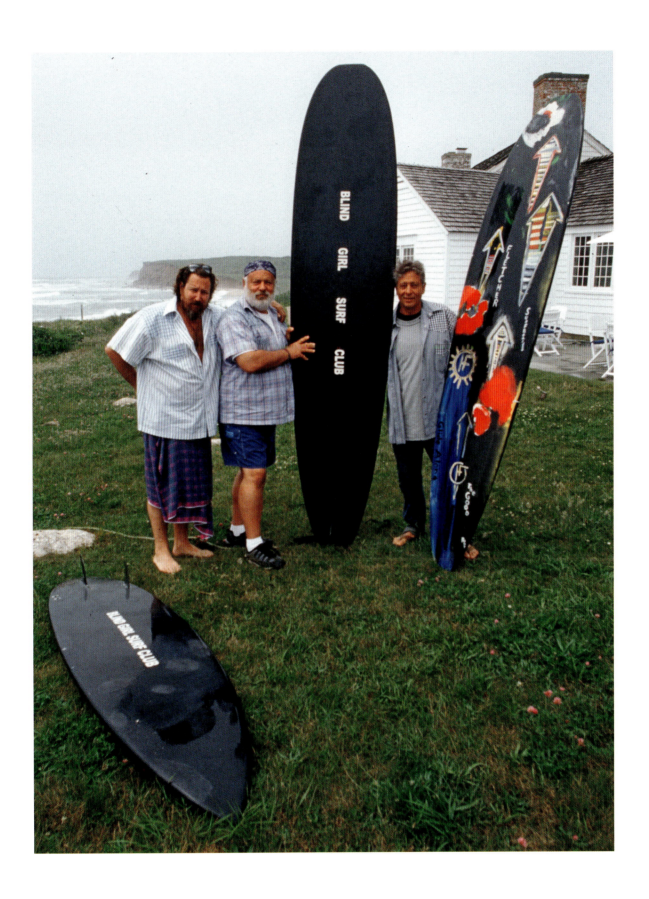

# BACK IN THE DAYS

## BRUCE WEBER

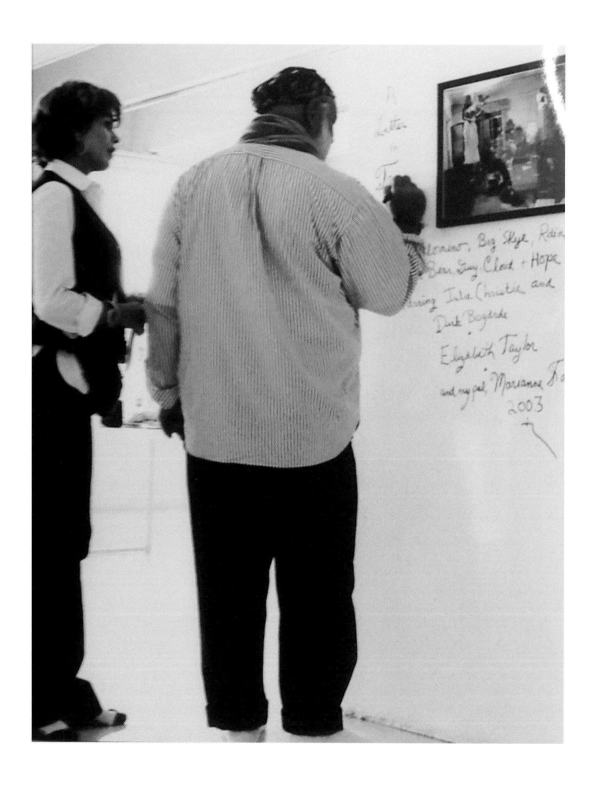

What's in the name Dibi Fletcher? A little bit of a young Ann Margaret in *Viva Las Vegas*, a touch of my history teacher Mrs. Farnum, who was a graduate of Vassar College and drove a vintage Austin Healy convertible to class. Dibi is a grandmother not unlike the original Auntie Mame. She has a smidgeon of the likes of Jack Nicholson in *The Shining*, just like the personalities of her sons Christian and Nathan. Her "hair wars" with Christian are legendary in the fashion world. When the boys first showed me their bedrooms, it seemed like they hadn't been cleaned in two years. Now, I'm not saying that Dibi doesn't keep a well-kept house in San Clemente, but her son's bedrooms have always been off-limits to a vacuum cleaner—and forget about "Make your bed!" Walking through the living room, you could trip over Herbie's paintings of broken surfboards. What I really want to say is . . . her home has never had a decorator; it's as if everything is an installation from a curator of California Beach Culture! Mainly because of her dad, Walter Hoffman (an original member of the Malibu Mafia), and, of course, her Uncle Flippy (a famous waterman), who wore his wet suit as pajamas at his house on the beach. Her beautiful mom loved ballroom dancing and both mother and daughter could have won Dancing with the Stars. Everywhere in Dibi's house and studio exists something brilliant and eccentric made by her—a painting, or a sculpture of stone resembling one you would cherish picking up on the beach near the old house of their neighbor, President Nixon.

A sense of four-letter words engraved, ghostlike, and nowhere written—but secretly expressed in the form of rebellion. Someone might compare Dibi to a female version of Henry Rollins and his spoken words at a Black Flag concert. Her family is the epitome of surf royalty: see her constant Instagram posts, her writings, and her dad's immensely famous collection of surf boards dating way back before The Duke. Her sister, Joyce Hoffman, is a champion surfer and the photographs Dibi has shown me of her riding tandem is kind of like that Lou Reed's song, "Walk on the Wild Side," mixed with the conservatism of eating a surf 'n' turf meal. For me, knowing Dibi has been compared to "walking a tight rope between two cliffs jutting out to sea." I've learned from her to "tough-love" my friends, which is better than "no love at all." I learned to put the truth out in all my work, thanks to her, and "say it like it is" and "walk the walk." Knowing her has helped my relationships with humans, dogs, cats, elephants, orangutans, and, I guess, skaters and surf warriors. I've been dreading writing about Dibi for her long, long-awaited book (already a classic before it's finished).

I just want to say, after all these years, the good times and the miserable ones, "I love you Dibi" isn't enough. It's better that I throw her three kisses and two to Herbie, for throwing at me, Nan, and our dogs a lot of unexplainable beauty, family, and art into this crazy world of ours—kicking and screaming like hell, with repeating echoes again and again. "Don't be afraid to open your eyes!" It can't hurt you.

Dibi – if you don't like this make a paper aeroplane out of it XO B.W.

# HOLLYWOOD ALOHA

I first met Walter in 1955 when I was four years old. My mom, a divorcee with three kids—my older sister Joyce, younger brother Tony, and me—had plans to rent out the room off the garage, kind of a standard practice on Balboa Island. I remember hearing a knock. I ran across the UPS-brown linoleum floor to throw open the front door. I look up from all of my 42-inch height to see this mountain of a guy standing in the doorway. He looked down and smiled at me. I liked him instantly. I screamed "Mom," and while we waited for her to come to the door, I had a chance to check out this stranger. He had a beautiful mahogany ukulele under his suntanned forearm, which I could see because he had cut the sleeves off his blue Makaha Surf Club hooded sweatshirt. His huge bare feet had thick calluses from spending most of his time barefoot, just like my feet. He was wearing blue denim trunks with two white ribbed stripes sewn down the side of each leg. I would find out later they were made by Taki's, one of the first important brands out of Honolulu who catered to the beach boys in Waikiki. At twenty-four years old, Walter had just moved back to the mainland from his four-year stint in the Navy. While stationed at Pearl Harbor on radio duty at night, during the day he had the freedom to pursue his passion for surfing and shaping balsa wood surfboards on the beach at Makaha. This giant of a man had a relaxed confidence that I immediately responded to. I was intrigued.

The deal for the room rental was struck and Walter started the move-in. The space was small, so he put his hi-fi in the front room of our house, along with his steel guitar. He brought the music of the islands into our lives with him. It was wonderful listening to Genoa Keawe and The Richard Kauhi Quartette while he strummed along. He told us stories of going to the Seven Seas Club on Hollywood Boulevard, where he took steel guitar lessons while attending Hollywood High. It was great having him around. As we became more comfortable together, all his friends began stopping by.

Walter had grown up in the Hollywood Hills with his brother, Phillip "Flippy" Hoffman. Their father, Rube P. Hoffman, was a textile converter, who began his business, Hoffman Woolens, in 1924, from an office/warehouse on 7th Street in downtown Los Angeles. He experienced rapid success as a wool supplier and importer of other types of fabrics with the fast-growing California economy. He changed the name to Hoffman California Fabrics, International to reflect the opening of global trade. Walter and Flippy lived in relative prosperity and spent most of their teens surfing up and down the California Coast with like-minded friends. Walter's return to the mainland also meant his joining his father's business. There he cultivated clients who were tapping into the new youth culture with the companies' fantastic prints inspired by Walter's love of the ocean and beach lifestyle.

It was the mid-'50s, and California was building at an unbelievable pace. Finally at peace after WWII and the the Korean War, people saw prosperity and had hope. Art and design flourished in this new era. Many European artists had fled the war-torn countries of their birth to settle in the warm sunlit expanse of the great western frontier. Young servicemen returning from overseas headed to college on the government "GI Bill of Rights Plan." The aerospace industry, which had made such a huge contribution to the war effort, turned their attention to making durable lightweight products that would transform everything about the way the newly liberated car-crazed Californians were going to live. The new aluminum sliding glass door opened the homes to outdoor living with chic molded chairs, where Hawaiian printed shirts were a staple for backyard barbeques after a day of surfing. With surfboards evolving from 100 lbs. of solid wood to 40+ lbs. using the foam and fiberglass that had been invented for lighter aircraft, surfing was more accessible than ever, and mid-century modern casual outdoor living was the American Dream.

Patterns were everywhere: wallpaper, upholstery, curtains, rugs, and certainly clothing. Designers specifically targeted the active lifestyle enthusiast; and right-place right-time Hoffman Fabrics was there. From the swimwear designers of the early times to the young startups that sought the beach goers specifically, my Dad, with a large in-house art department, help create the "surf look" with the prints they produced.

After some business success, Walter and my Mom were married in 1958. The young father and his readymade family moved father south and bought a house in Capistrano Beach at the end of a 2 ½-mile private street named Beach Road. When I first saw the little house, it was uninhabited and uninviting, but Dad took one look at the surf in front of the house and decided it was heaven. It didn't matter that he was going to have to commute to and from Los Angeles every day for work. It was worth it to him—it was his dream to hear the surf outside his bedroom window when he got home after dark in the winter. On weekends he could grab his board

and walk right out the sliding glass door, across his beach, and into the surf. The house next door was owned by Wayne Schafer, a bachelor and one of Dad's high school friends. He was a marvelous host and opened his doors and beach to their mutual friends who had made the most of this new casual way to live a contemporary beach life. They started businesses with an entrepreneurial zeal that catered to the beach enthusiast. Textiles, music, restaurants, magazines, board shorts, surf movies, catamarans, dune buggies, surfboards, new logo-driven t-shirts all were part of the burgeoning surf culture packaged for mass consumption, eventually earning them the name "The Dana Point Mafia." My Dad was "The Godfather of the Surf Industry" according to the 1990s press.

In the early '60s we were spending every Christmas in Hawaii so my Dad and older sister, Joyce, who was competing for the Women's

World Championship, could surf perfect Hawaiian conditions. We would spend a few weeks on the West Side, while my Dad judged the Makaha Surf Contest, which he had won in the early '50s, and in which my sister and I now competed. I was 14 years old, practicing tandem lifts with my partner one day on the lawn of our rented condo for our upcoming contest heat when a young guy approached and randomly asked if anyone knew "Joyce Hoffman." This guy, with his long shaggy hair, didn't look like anyone my sister would be hanging around with. I asked who he was and what he wanted. He said his name was Herbie Fletcher, and said someone told him Joyce had his lost surfboard . . .

In the beginning...1951
surfing was just part of the lifestyle

# FAMILY FLETCHER

## C. R. STECYK III

The surname Fletcher occupationally means arrowsmith. Herbert Edson Fletcher has spent his life crafting projectiles. He is a sculptor by inclination and an artist of motion.

1965, Huntington Beach California, aka Surf City. The son of Lois Bunting, a Cherokee who had been adopted and transplanted by Nazarene missionaries, wins the Boys division of the West Coast Surfing Championships. Herbie Fletcher is drafted as test pilot by master designer Phil Edwards and surfing's biggest manufacturer, Hobie Alter. In the previously described process he becomes one of the first professional surfers.

Crosscultural innovation is his clan's modus operandi. They relentlessly pursue their visions despite the consequences. The recitation of a litany of the clan's ridiculously prescient acts is in order.

The Patriarch:
The trailblazing clay-wheeled skateboard original swimming pool rider. Anyone got photographic proof of an earlier pool?

He is creator of the original Astrodeck traction decks as well as the first kicktail pads for surf craft; an inaugurator of post modern longboarding; the introducer of tow in surfing. And the pioneer of contemporary surf verité cinema.

The Matriarch:
Girls in the curl? Long before there was a Gidget, there was Hawaiian semi-deity Mamala, who was part woman and part shark, worshipped for her shapeshifting and wave riding abilities.

The oldest surviving *papa he'e nalu*, (ocean sliding board) belonged to Princess Kaneamuna, who rode it in the 1600s. Kaneamuna rode the torrid Pacific Ocean while Shakespeare stood still on stage at Stratford-upon-Avon. Women in the water are not a contemporary manifestation.

Deborah Charlton Hoffman Fletcher comes from a distinguished *kama'aina* clan. Her father Walter and uncle Phillip Hoffman are pioneering watermen. Big Sister Joyce was a World Champion in addition to being the first woman to ride Pipeline.

Young Dibi competed in the tandem event at Makaha for several years. She retired in 1965 shortly after meeting Herbie there. The pair subsequently ran off together, eventually getting married in 1969.

Dibi was the only girl ensconced top dead center in the North Shore scene during the tumultuous ending of the sixties. And now that boardsports are a nineteen billion-dollar-a-year proposition, guess who is the last woman standing? Today she is revered as the first female CEO of boardsports.

Mrs. Hoffman Fletcher's status as a third generation *garmenta* equips her to excel in current broad-based entrepreneurial exploits.

Dibi's other day-to-day endeavors involve running Astrodeck; negotiating assorted sport, film production, music, literary and fine arts contracts; continuing her writing and configuring the required structure to accommodate a wide array of familial art projects. She continues to sculpt and paint when the mood dictates and her morning grueling 26-mile bike rides would drop lesser mortals. The United States Marine Corps awarded D. Fletcher a commendation in recognition of her counseling efforts with Afghanistan and Iraqi war veterans.

Number One Son:
Christian Li Fletcher was born in Hawaii in 1970. When he began throwing big skate aerial moves in the sedate and rigorously controlled pro surf contests in the 1980s and early '90s, he fomented a revolution that fundamentally changed the evolution of the sport. Ostracized by the status quo for his innovations, he received ridiculously low scores and vile verbal and printed abuse. Christian's harsh, humorous response critiques of these organizational tormentors, which he unleashed in popular publications, earned him the enduring enmity of the entrenched power brokers of the surf industry.

He remains the only person ever to have appeared on the covers of *Surfer*, *Esquire*, *Thrasher*, *Surfing* and *Breakout* magazines.

Grandson One:
Greyson Thunder Fletcher who was born in 1991 is generally considered the best free skater on the contemporary scene. The reluctant star of HBO's series *John From Cincinnati*. He barely recalls the cine grist and grandeur of David Milch's Deadwood By The Sea.

Christian and Greyson share the unique bond of choosing to live off the grid.

Wandering Son:
Displaying the ancestral *de rigueur* insolence Nathan Walter Fletcher, born in 1974, worked hard at getting lost in music of his own making. Walking completely away from professional surfing he preferred composing amidst an endless, trackless landscape of moto airs out in the desert. Those unstructured meanderings involved thousands of miles of transfers, landings and giant drops, which a half decade later morphed back into a nomadic existence chasing massive waves. Nathan's return was characteristically underplayed as he launched unplanned assaults with spontaneous improvisation. Giant Mexico. Big lefts at Mavericks. Going deeper and bigger than all comers on a code red swell at Teahupoo, Tahiti.

His accomplishments include advancing the four-fin design, capturing the Quik Cup for crossover surf/ skate and snowboarding, winning three Billabong XXL Big Wave Awards in a single year, and leading the paddle in revolution of big surf high performance.

Grandsons Two and Three are coming for us all. Be forewarned.

To declare that the Fletchers are the most influential family in the history of the surfing world would be an understatement. Family F has never followed the rules and they don't ever ask permission. Their credo is "If you know, you go." It's as simple as that.

My sister, Joyce, was the first woman to have a signature model surfboard 1966

## Tandem champs.
## Joyce Hoffman-Triumph Spitfire Mk2

Why did "The Blonde Goddess of the Waves" select the Triumph Spitfire Mk2 as her official beach buggy?

Is it the car's outstanding styling and performance? (Plush, fully-carpeted interior. Smooth 4-speed stick shift.

0 to 50 mph in only 10 seconds.)

Safety features? (Accurate rack-and-pinion steering. Reliable disc brakes. Tight 24-foot turning circle. Bump-smoothing four-wheel independent suspension. And steering column designed to collapse upon impact.)

Economy? (Only once-every-6,000-miles lubrication. Price: only $2155*.)

To tell the truth, we really don't know. All Joyce said was: "It's so me!" Ah, women!

**TRIUMPH**

# FREE AND EASY

It was 1965 when Herbie left home in Huntington Beach at sixteen years old. Huntington was a volatile mixture of blue-collar workers, surf gangs, bikers, and Mexican immigrants working in the tomato fields and on the oil rigs that covered the bluffs overlooking the Pacific. It was eclectic mix of crime and creativity. Ike and Tina Turner played at the Pavilion while Dick Dale was creating the sound of surf music at the Rendezvous Ballroom. Herbie had recently started entering surf contests, and with a few major wins under his belt, he was hired by Hobie Surfboards to appear in a commercial filmed by Bruce Brown. With his 250-dollar paycheck in his pocket, Herb left home with the clothes he was wearing, a surfboard, trunks, and a bedroll, and headed for paradise, the North Shore of Oahu. Living in the back seat of Dewey Weber's rusted-out '56 Cadillac was a little bit rough; then again, at first light when he could see the waves peeling at Sunset Point, he knew his decision to leave home was the right one. He did odd jobs for a few bucks to keep eating, surfing, and pitching in for gas when hitching rides to surf other breaks. Once, he barely made it to the West Side to compete in the Makaha International Surfing Contest—which is where he and I first met.

Not long after we met, Greg MacGillvary hired him to star in his film *Free and Easy*, Herb figured he had it made. WOW: being paid to surf—a dream come true. The pay wasn't much by today's standards, but he had a place to crash, a ride to the beach, and the opportunity to fly to Maui to surf Honolua Bay with no one around. He was completely stoked! By mid-'66, MacGillvary had left Maui, and it wasn't long before Herb figured that sleeping alone among the spirits in the Buddhist graveyard and living on peanut butter sandwiches was all good when the waves were pumping, but his board was thrashed and he needed new equipment. It was time to head back to the mainland and make a few bucks. Winters in Hawaii and summers in California became his way of life for the next few seasons.

Two years after our initial meeting at Makaha, I had the grand idea of leaving home in the summer of 1967. Herb had just returned to Laguna Canyon from the Monterey Pop Festival when I arrived on his doorstep to inform him of "our" plans. He was a bit hesitant, but I convinced him, with all my youthful bravado, that he could handle it. After our brief stay in the Canyon, with the some of the more notable characters in the Brotherhood of Eternal Love, we were off to Maui. Many of them decided to follow after Herb introduced them to the joys of surfing, and the small quiet island paradise was soon became the Haight Ashbury of the Pacific. What had started out as a great time began to lose its luster for us, and it was time to head to the North Shore.

We packed up and moved into my dad's house on the beach at Pupakea. He was still pretty upset about my sudden departure from home the previous year at sixteen with Herb, rightly feeling that with no education, no skills, no formal training we were destined for failure. We had a plan, and maybe it was just wishful thinking, but you couldn't help but notice how the surfers multiplied over a couple of years in the islands. Where Herb used to have solitary footprints in the sand at Pipeline, now, there were surfers in the lineup and they all made sure to have enough cash to buy a great surfboard. We called Gordon "Grubby" Clark, who had invented the process of blowing foam for surfboard blanks back when I was eight and he was recuperating from back surgery next door. We had always remained friends, and so with my Dad's signature for credit, we secured the Clark Foam franchise for the Hawaiian Islands.

Herbie built a shaping room in the backyard and continued experimenting with the down rail design that he felt changed how his board moved through the water. The house on the beach became a gathering place for all sorts of surf characters refining the science of surfing. He was inspired, being able to shape and glass a board at night and paddle out in the morning to get instant feedback on his design ideas. He seemed to have found a rhythm that propelled him into more experimentation and also satisfied his artistic sense of creativity, using all the excess resin with added tints and pigments to create paintings. Art, function, functional art—it was all the same.

In fall 1970, we welcomed the birth of our first son, Christian. He was perfect, although Herb was concerned that he was left-handed, meaning that he was most likely a goofy foot. Being a lefty myself I was more interested in the idea that he was so predominantly one way and not more ambidextrous. While Herb was filled with youthful visions of Christian surfing switch-stance, I was starting to look around and see the world through the eyes of a mom.

The North Shore, with its flawless surf, relaxed lifestyle, no phones, newspaper delivery, or TV, was a magnet for all sorts of people looking to fly under the radar. There was a thriving underground economy that helped fund so many of the surfers with their travels in search of pristine waves around the globe. Compared to the living conditions of the locals there was a growing discontent that would flare up as soon as the sun went down, it was time to leave.

We moved back to California and started the Herbie Fletcher Surf Shop in Dana Point with the slogan "The Thrill is Back"—and it was. The business of "surf" was exploding, and Orange County was its hub. The seeds of business that had been planted with my dad and his friends was now a thriving industry. The trade shows twice a year, part work, part party, were a testament to the growth and global interest in surf. Herb had been experimenting with some new material that could be applied to the deck of the surfboard for better traction than the existing wax. He soon closed the surf shop and opened a manufacturing facility in San Clemente and started producing Astrodeck. We had our second son, Nathan, during this time.

With the extraordinary challenge of bringing a new product to market, and two young kids who were up for every kind of action sport fun, it didn't take long for the siren song of aloha to capture Herb's attention once again, and in '81 we made an investment in a house at Pipeline with Jerry Lopez. This was the beginning of the MTV generation, and Herb, who had always loved filming, thought making videos was the best way to showcase Astrodeck. He had his custom Jet Ski shipped to Hawaii so he could launch from the front yard when the surf got huge. His full-time camera man would live at the Pipe House for the

season to capture the greatest tube riders in the most critical conditions that showcased surfing, ride and waves most people had never seen before. It was all shot on film and had to be processed in Hollywood, where Herb would spend nights at the Record Plant working on original songs with many of the musicians he had become friendly with when he and a longtime friend and occasional business partner did rock 'n' roll promotions. *Wave Warriors* became the first video sold in surf shops and it created a bond between all the surfers who were included in the five series that have become part of surfing's great past. Herb went on to produce more than one hundred surf video titles, thousands of stills, surf traction, documentation of surfing's aerial revolution, jet skiing the outer reefs at Pipeline and the beginnings of tow-in surfing. The late '80s and early '90s was a fantastically creative time in surfing, and with our two sons, we were living the dream, fortunate to have complete trust in each other's ability to handle whatever came our way.

We've designed and produced snowboards, wakeboards, bindings, clothing, all the ads, catalogs, and tradeshow booths. We've done all types of art, which has always been our passion. Since Herb's first resin paintings in '66, he has used traditional surfboard building materials in new and unique ways. With his signature Wrecktangles, made from the boards of the greatest contemporary surfers all broken at Pipeline and assembled as sculptures, Herb continues to tell interesting stories about surfing into the twenty-first century.

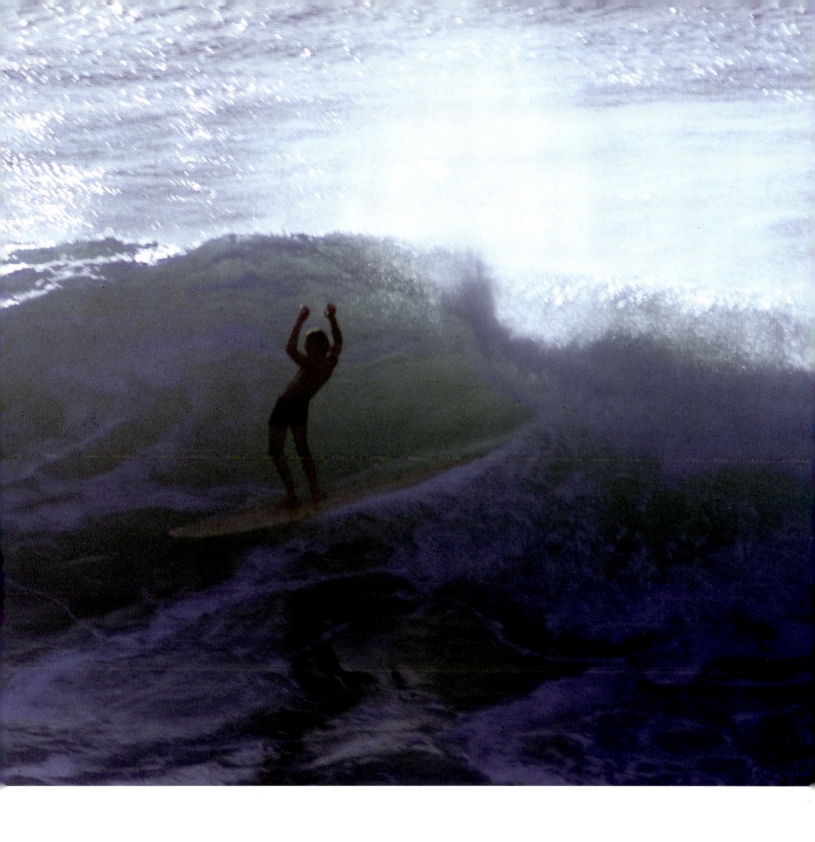

Herb & I first met in
Hawaii in 1965

69 Herb Pipeline

Leroy Grannis

Casting

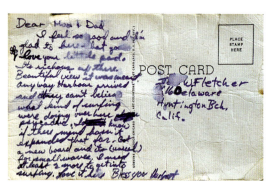

Dear Mom & Dad
I feel so good and I'm
glad to be here but you
love you little gaol.
Its nice here out there.
Beautiful view it was meant
anyway Harbour arrived
and they can't believe
what kind of surfing
were doing over here
on weather. I don't know
if there might happen to
expanded that far. Got
a new board and fin (wessel)
for small waves, I need
at least 2 more to get into
surfing. Love it here Bless you Herbert

POST CARD

PLACE
STAMP
HERE

W Fletcher
160 Delaware
Huntington Bch,
Calif.

ORANGE COAST

MAGAZINE SECTION OF
THE DAILY PILOT/NEWS PRESS
FRIDAY, OCTOBER 1, 1965

# WEEKENDER

A STORY AND PIC-
TURES OF SOME OF THE
WORLD'S GREATEST
SURFERS RIDING THE
WAVES DURING THE
U. S. SURFBOARD
CHAMPIONSHIPS AT
HUNTINGTON BEACH
ARE ON PAGES 8 AND
9 OF THIS ISSUE.

THE HOUSE DOCTOR
TELLS HOW TO RE-
MOVE MARKS FROM
FURNITURE, CAUSED
BY BURNS AND OTHER
ACCIDENTS, IN HIS
COLUMN WHICH MAY
BE FOUND ON PAGE 7.

THE MEET THE PEOPLE
PEOPLE THIS WEEK
INTRODUCES THE NEW
MANAGER OF THE HAR-
BOR AREA'S ONLY
GOLF COURSE THAT IS
OPEN TO THE PUBLIC.
YOU CAN FIND IT ON
PAGE 3.

## THE BIGGEST AND BEST IN HB

Huntington Beach Ind.-Review, Thurs., Sept. 29, '66  F-3

TWO TITLISTS — Sue Bruderlin, Surf Queen and Miss Huntington Beach, with Herbie Fletcher, who won title of "Huntington Beach Boy" in Eighth Annual U.S. Surf Championships held Saturday and Sunday at Huntington Beach. An estimated 44,000 saw beach city classic.

Ex-Bolsa Star Walker Says

# World Surf Contest Opens

## Defending Champion Withdraws

SAN DIEGO — The power-packed United States West Coast team, headed by Huntington Beach king Corky Carroll, ruled a solid choice today as action got under way here in the World Surfing Championships.

Vice - President Hubert Humphrey and Governor Pat Brown officially opened the third annual event this morning by welcoming representatives of 11 countries to the water sports carnival.

Officials of the meet were shocked Monday to learn of the withdrawal of defending champion Felipe Pomar of Chile.

Eduardo Arena, chairman of the Peruvian team, made

MEETS WORLD'S BEST — Herbie Fletcher of Huntington Beach displays his nose riding ability in preparation for today's opening competition in the World Surfing Championships. Fletcher is a member of the United States West Coast team.

SPORTS

Better-Alston

## Dodger Smilin' Time

# HERBIE FLETCHER

## KELLY SLATER

Speaking of visionaries, Herbie Fletcher single-handedly developed deck pads at Astrodeck in the early '80s, something every surfer on earth now uses. From the time I was ten years old, he sponsored me for a decade, and eventually created the greatest surf team the world will ever know. He was riding giant surf on a jet ski before anyone else, which ultimately led to tow-ins and water safety measures in big surf. Herbie has been one of the greatest longboarders and designers of all time, made some of the most memorable surf movies ever, and crossed into mainstream via surfing places very few ever have gone.

He's also deeply entrenched in photography and art, working with legends in both fields. The Fletcher and Hoffman families are synonymous with surfing and both Nathan and Christian have always been ahead of the curve pushing the limits of aerials and board design, something Dibi and Herbie instilled in their DNA. On top of all that, his grandson Greyson is one of the world's greatest skaters. What lineage! We all owe a debt of gratitude to Herbie in the surf world for pushing the boundaries for all Wave Warriors!

*Herb surfing the fastest wave in the world... Maalaea, Maui, 1976*

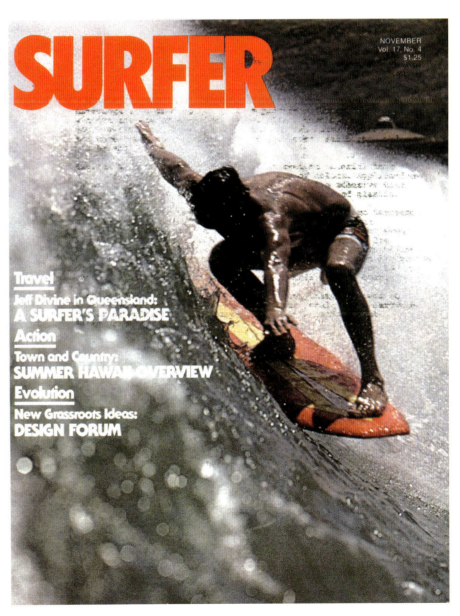

NOVEMBER
Vol. 17, No. 4
$1.25

# SURFER

**Travel**
Jeff Divine in Queensland:
**A SURFER'S PARADISE**

**Action**
Town and Country:
**SUMMER HAWAII OVERVIEW**

**Evolution**
New Grassroots Ideas:
**DESIGN FORUM**

Through constant surfing and constant testing, Herbie Fletcher is constantly tuning the freshest, most fun to surf ideas in surfboards. The thrill is back.

Bill Hamilton's special models are available through our California shop for the first time, exclusively at Herbie Fletcher Surfboards.

Speed Racer: length 7'10", width 20", nose 12⅛", 11" pintail. Tunnel tested to put the thrill back in your surfing.

# CREATING THEIR OWN CONTENT

## MIKE DIAMOND

Me and my band owe the Fletchers a debt, as I'm sure many do from other different worlds and pursuits. Let me explain: my bandmate Adam Yauch LOVED snowboarding. I mean, there was a period of his life when he was so obsessed, so focused, so fucking into it. It was almost an all-consuming passion, except he still had his day job—being in a band with me and Adam Horovitz called Beastie Boys, which didn't suck either. We would be working in the studio we built on the East side of LA and Yauch would get a snow report from Utah, and he would take off, leaving us sitting there like, "oh, I guess we're not working the rest of this week."

He kept a spot in Utah for some years, sharing it with various pros, kept an upright bass there, some clothes, gear, and not much else. At some point, I don't know how, but he meets Nathan Fletcher, then an aspiring teen snowboarder whose parents sent him to the mountain with the condition that he film almost everything. Who does this other than Herbie and and Dibi? Anyway, Nathan eventually ends up living in the same Utah house as Yauch, and Yauch becomes friends with Christian.

Back in California, Christian takes Adam down to Herbie's San Clemente video-making HQ. Somehow they get to talking about videos and how bands like us make videos at the time, and Herbie shows Adam the whole set up: editing bay, all the finished VHS tapes, etc. It was a totally independent film company. Dependent on no big company to approve a concept or send a check or insist on some big-name director. At that time, for bands, you had to come up with a concept for a video and show it to the record company only to have the shit re-written, and then they would say, well, we think you need to work with director a, b, or c, and then the idea would get literally thrown away and you'd be spending a shit-ton of your own $ (yes, you are on the hook for half) on something you weren't into. We didn't want a part of any of that. We were from punk and hardcore and rap. We were used to sneaking into offices at school to use Xerox machines to make our own damn flyers. So Adam sees what the Fletcher's have going on and is like, "What? We should be doing this."

To his credit, Herbie really pushed Adam, insisting he could do this, giving him a list of equipment to buy, etc. Before we know it, Yauch is back at our studio not just talking about these videos that we could make; he just started filming shit and in his house, he started to edit it. This was not how bands on big labels operated at the time. It was as revolutionary as Herbie or Christian's surfing or their ways of doing business,s and it was all inspired and enabled by them. Thanks guys! We owe you.

# FLETCHER DNA

## BARRY MCGEE

Dibi and Herbie are the surfing pioneers that live within our collective consciousness. They embody the electric and awe-inspiring energy of timeless and fearless youth. The legendary Fletcher/Hoffman DNA has continued to inspire generations of surfers and skaters for almost a century. Dibi and Herbie are equal partners in this dance. Both are respected artists. Dibi is a sculptor of stone, a writer, and the archivist of the Hoffman/Fletcher histories. Herbie—artist, sculptor, and pioneer of surfing that was ahead of the time, ahead of the masses—is legendary. While many others of Herbie's generation have set down their boards and long for their past, Herbie is still out surfing 100% balls to the wall. Their kids Christian and Nathan made their own legacy from powerful shortboard surfing, often above the wave, launching far into the air before anyone had any idea how to get there. The Fletchers lead the way for future generations to explore new territory within surf culture. With impeccable style and, grace, and unsurprisingly, the first of the next generation, their grandson Greyson, continues the Fletcher DNA legacy. The only explanation is their royal bloodline rose from the depths of the sea itself.

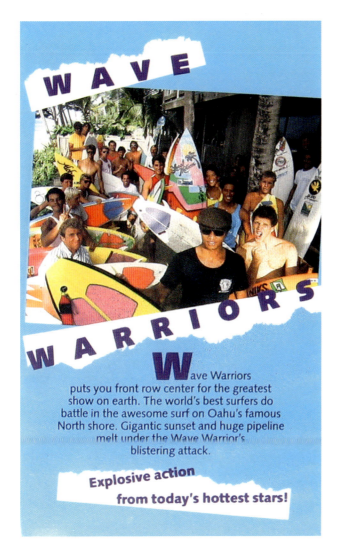

# WAVE WARRIORS

**W**ave Warriors puts you front row center for the greatest show on earth. The world's best surfers do battle in the awesome surf on Oahu's famous North shore. Gigantic sunset and huge pipeline melt under the Wave Warrior's blistering attack.

**Explosive action from today's hottest stars!**

ASTROBYS *Presents*

## WAVE WARRIORS II

WORLD PREMIER — ALL NEW FOOTAGE IN STEREO

**C**ut to the bone, hardcore or nothing: Wave Warriors II does *not* screw around. The video you're holding in your hands is a straight-up, wire-to-wire, rock'n roll surf explosion . . . just the best surfers in the world cutting loose in the world's best surf.

**HARDCORE, REDEFINED.**

**PLUG IT IN AND GET CHARGED.**

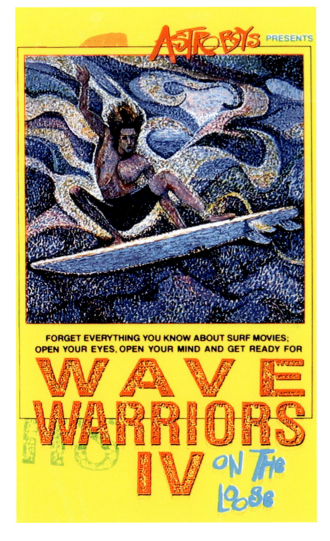

ASTROBYS PRESENTS

FORGET EVERYTHING YOU KNOW ABOUT SURF MOVIES; OPEN YOUR EYES, OPEN YOUR MIND AND GET READY FOR

## WAVE WARRIORS IV
### ON THE LOOSE

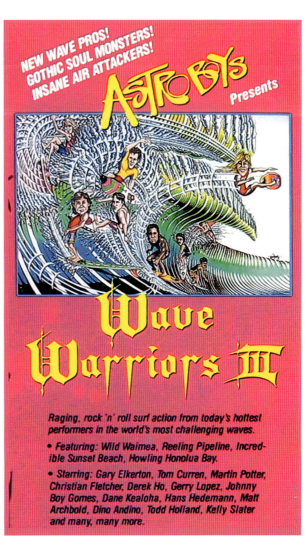

NEW WAVE PROS! GOTHIC SOUL MONSTERS! INSANE AIR ATTACKERS!

ASTROBYS *Presents*

## Wave Warriors III

Raging, rock 'n' roll surf action from today's hottest performers in the world's most challenging waves.

- Featuring: Wild Waimea, Reeling Pipeline, Incredible Sunset Beach, Howling Honolua Bay.
- Starring: Gary Elkerton, Tom Curren, Martin Potter, Christian Fletcher, Derek Ho, Gerry Lopez, Johnny Boy Gomes, Dane Kealoha, Hans Hedemann, Matt Archbold, Dino Andino, Todd Holland, Kelly Slater and many, many more.

Herb took the medium he knew
and created a new story

# FLETCHERS FLEXIN' FULL FORCE

## ROBERT TRUJILLO

Creative progressive sarcastic honest dangerous reckless mofo-motherfuckers (positive!) heathens warlords thinkers philosophers (Venice Dogtown–style) renegade-pioneers feral untamable untrainable funky fuckin' fashionistas! Rebels (Rebel! Ha!) fearless chainsmokers.

Welcome to the Fletcher boys, cos' this is the core of their DNA as I always found (and find) it.

I'm always amazed by tales of the urban warriors, and I dig the "edge and attitude" type of athletes, artists, and musicians who push the limits. Sometimes those limits and boundaries require near-death experiences, or just straddling that line between the bright side and the dark side (heaven and hell, ha!). Jimi Hendrix was that daredevil on guitar, and, trust me, there are daredevil musicians who must have nine lives and are lucky to be alive—I think I've played with most of them, even inheriting those extreme edge-of-your-seat moments at the height of their wild personalities. Blessed? "HELLO, Suicidal Tendencies. HELLO, Ozzy Osbourne. HELLO, Metallica. Fuck yeah thank the gods of creativity and r'n'r because I've been blessed. Which of course also includes, HELLO, The Fletcher Boys. By the way, I've got to tell you: If I'd had the chance to rip it up with the Fletchers in a band, it would've made free-form craziness seem conventional—the sounds, the words, the grooves and riffs, the album covers. I can only imagine!

Through the mid- to late '90s Christian Fletcher and I snowboarded from Big Bear to Mammoth, always charging, racing through ravines and chutes, jumping off ledges. He would always experiment with alternate routes (off-piste), forcing me to push my limits and actually become a solid snowboarder. Christian also got me riding shorter, more progressive-shaped surf boards. And now he's getting me into riding crazy cutting-edge longer shapes. I don't deserve to ride them, as they are works of art—his art incidentally, he creates the visual concepts—and really, these boards should be in art museums! I remember surfing with him at Trestles and was highly entertained by the fact that he could punt a "fuck-you" ollie over the bodyboarders on the inside section. I even remember him tackling one of my friends who took off on him, and today I still see the fear in their eyes from the incident.

Bottom line, Christian Fletcher supports all artists and their creative ventures, including my wild experimental progressive punk-funk-bass–driven band Mass Mental. I mean, Mass Mental has only played about four shows in eighteen years, and CF has been to all of them.

Another example of support? Christian bought his father Herbie (the OG Fletcher, and that's no exaggeration!) to see my doc film *Jaco*. Did I mention Christian was there in a wheelchair with a broken femur?! Point being, Christian Fletcher—a true spirit of the arts—supports them and is always thinking of ways to be that bridge that connects the individuals he respects. Whether it's artists, fashion designers, kustom car hoodrats, musicians, gangsters, daredevils—not just surfers and skaters. During the Ozzy tour in Maui, I surfed Rainbows with both Herbie and Christian on a super-fun day. I was amazed at the connection to the ocean Herbie had, an intuition as to when the sets would hit and where we needed to be. I noticed the same

connection and intuition on the North Shore. And later that night, his spiritual awareness (and my intrigue) led us to the Tyson/Holyfield fight. I think it was the one where Tyson bit Holyfield's ear off. Put it this way, there's a symmetry there, given I was with the Fletchers!

Despite all that energy and beautiful creative chaos (which would be a 24/7 proposition for any household) guess what? The atom split, and Mrs. Dibi Fletcher decided one Fletcher son wasn't enough. Enter Nathan, who you'll be unsurprised to learn shares the same daredevil genes. Like father, like son. Trust me when I say those Fletcher waters run deep. Hey Herbie, what's IN that seed?! Hey Dibi, what's IN those eggs?!

Back in 1996, I had connected with a young and very respectful Nathan in Las Vegas for the circus known as SIA Show/Ski Trade Show, where anything is possible, from board-sport celebrity full-combat mode throw-down boxing events to dinner with your surf and skate heroes (all of them in full cocktail mode, of course)! The Fletchers were involved with Think Fast, Christian Fletcher snowboards, and Astrodeck pads. Hang on, flashback (Fletcher-style here, hahahaha) I do remember back in 1989, it was Nathan who was rumored to have been invited to play guitar with thrash icons Exodus when Suicidal Tendencies, Exodus, and Pantera rolled into town to perform a highly anticipated thrash metal/punk extravaganza at the Bren Events Center in Irvine, CA. I knew Christian has always been kicking ass on electric bass; in fact I gave him a bass and an amp. But Nathan at fourteen was about to take on an extreme universe of metal mayhem, experiencing multiple swirling mosh pits that could only have resembled the spinning barrels of Teahupoo, or the mighty Pipe. For whatever reason it didn't happen that night (Exodus lose!) but I DID see Nathan a little farther down the road at a Slayer gig in Hollywood in the slam pit with a broken leg, so for sure that spirit was always in him, and those thrash metal roots get expressed in the raging cauldrons of heavy water. I remember sitting with Nathan on the North Shore as he told me in detail

the spiritual value of his near-death wave warrior wipeout, in relation to a couple of very close fellow wave warrior brethren who had recently lost their lives in the ocean. Another time on the North Shore, the day after Pipe Masters, which everyone was "recovering" from, I thought I'd be clever and paddle out to beat the crowd. I was nervous about who would be out there in terms of "enforcers," but to my great fortune and blessing, Nathan was out there so I got my ghetto pass. The waves were fun, averaged size suitable for me, and Nathan later told me that session ended in some of the biggest and most perfect pipes ever.

And then we have Greyson, Son of Christian (makes him sound like he's from Game of Thrones huh, well I guess that could be the Fletchers hahahaha), who is the ultimate hybrid Fletcher male. Humble, his confidence expressed through body language and the arc of his skateboarding rhythm, Greyson's a humble stylemaster on and off the board. He was at a Dogtown event with some of the legends of the D-Town skate scene and he actually didn't skate because he was there out of respect for them and not to strut his own stuff and bring attention to himself—classy move, I thought. He's the composed warrior of the concrete, who walks softly but carries a big stick, beer in hand but always in control.

One thing to recognize with the Fletcher Boyz is that they have major yin and major yang. On the one hand you can get down and fully spiritual-zen—master with them, sitting on rocks at sunset with the ganja flowing. On the other, the Fletcher Boyz deal with disputes in that hard-boiled spit 'n' sawdust way of the old school: fisticuffs and perhaps a sneaky joint to calm the dust. Crazy for sure, but it works for them. Must be that Native American blood. Surfing and skating is a different game. It isn't always easy, it isn't in any way always mellow. You've got to be wired differently to start with, and the Fletcher Boyz are wired beyond the wire's wire!

We should be grateful for that, because it gives us them.

# BLUE BOY

I always wondered if being left-handed made the difference. They say fewer than 20% of the population is. Christian and I both are, meaning we use the opposite side of our mind than 80% of the people we meet. Is this an excuse, an explanation, or just an interesting observation about how we see the world and how the world reacts to us? Christian was walking by nine months. I used to turn his playpen upside down and set it over him to keep him safe; otherwise if you turned your back for an instant he would have escaped. He knew no boundaries and with reckless abandon would climb up anything, jump off everything, hang out second-story windows at my parents' house, completely undaunted, and without the slightest recognition of self-preservation. He was completely fearless.

Herb loved it—he had the perfect little buddy to play with, and as Christian grew, he became a test pilot for many of Herb's inventions. Christian was very quick-witted, and had always been a good student; but by seventh grade, he seemed to be changing. His grades started slipping. His teachers told me "he's not very bright," and after months of searching I found a program that was geared to correcting learning disabilities. Christian was diagnosed; there was a long formal name, but the gist: he could only use one side of his brain. Within a year of training, he was better than ever but had completely lost interest in school.

He wanted to surf, skate, ride his motorcycle, get whipped into waves by Herb on his jet ski—anything to feed his adrenalin addiction. He'd ride his skateboard down to my parents' house on the beach, surf until dark, and call and ask to spend the night so he could surf before school in the morning. I'd ask him about clothes and he said he was good, he'd just wear my mom's—she always had the raddest plaid pants—and with his blue Doc Martens, he was completely comfortable. He had always been given lots of "surf" clothing, but his taste was heavily influenced by punk music and streetwear. He had an aversion to anyone thinking he was a surfer, which had become more pronounced after the Spicoli character surfaced in '82.

By the time Christian was fifteen, Herb was spending a lot of time at the Pipe House shooting *Wave Warriors*, and Christian and Nathan loved it. The house was the perfect setup, with its large wooden fence and securely locked gate to keep everyone out except for the most select group of fearless tube riders that Pipeline was becoming known for. These fit young local men that paced the yard, with their hair-trigger tempers, ready to fight at the slightest infraction of their unwritten code of honor—they were the guys who were pushing the boundaries in surfing, and the "surf industry" and their sponsorship dollars was blind to them. These street-tough, ukulele-playing surf thugs admired Herb in his fearless pursuit to ride closed-out second reef Pipe on his Jet Ski. It was something that had never been done before, and everyone thought it bordered on insanity. These guys, most in their early twenties, felt protective of ten-year-old Nathan, who was very gentle but who would also paddle out in big overhead tubes. They would naturally assume their role of water safety patrol to make sure the little brother was

always safe. Christian was different; he wasn't as reverential as they felt he should be, and he didn't care what they, or anyone else thought. Imagine Bob Marley and the Sex Pistols playing at the same venue? The friction was palpable and somewhat predictable whenever Christian was in the mix, and he seemed to thrive on it.

Over the next few years he spent a lot time perfecting different aerial maneuvers on his skateboard. Herb had always taken the boys skating, feeling it was the perfect way to train for what he thought would be the next progression in short board surfing: launching it into the air. From the trimming of my Dad's generation to the tube riding of Herb's, it seemed a completely natural evolution. No one could have ever predicted the uproar.

Christian with flying long blonde hair, fluorescent pink wetsuit, tattoos, and skull art on his boards—what's an industry to do when their goal is to sell back-to-school to seventh graders? Who was this upstart, launching airs over surfers paddling out to the lineup? His surfing style was great for selling magazines. The top twenty-seven pros wrote in protest, stating he should not be getting cover shots when they were the real athletes. They even complained that surfing should be more like tennis. And there was Christian, completely irreverent and intriguing to a broader youth driven market. He was shot by many of the great photographers working in fashion at the time and was featured in most the influential magazines on the newsstands. His section from *Wave Warriors III* was being played nonstop on every kid's VCR to the opening of the Guns N' Roses tour.

We were having so much fun, working hard, making movies, creating music, manufacturing Astrodeck,

putting on surf/rock 'n' roll events, collaborating with record companies, radio stations, the board of tourism—it was one big party, until it wasn't. From his radical aerial surfing style in the late '80s that is now, decades later, part of the requirements of modern surfing, to his brash, sometimes arrogant-sounding interviews that got him completely ostracized from the "established" surfing arena, Christian has been a lightning rod of controversy. Under the sometimes intense public criticism and scrutiny he has managed to live his life his way, as a complete non-conformist, kind of, to Hell with the consequences; a "I'm doing it my way no matter what" mindset. It really upsets most people, who love for the game of life to fit into a tidy format. I think sometimes, that's Christian's greatest gift: he makes you stretch your own boundaries, and as hard as that is sometimes, that's where personal growth happens.

He's funny, irreverent, and totally bizarre. Who knew there were hundreds, maybe thousands of juggling videos on YouTube? Christian did. He got it into his head a few years back to learn how to juggle. Now, he wants to share the videos with me and if I seem a bit bored, he's more than happy to share one of his favorite apps for tying a tie. Seem strange? I haven't seen him without a tie on for the last five years. It kinda goes perfectly with his leather shorts, button-down white short-sleeved shirt, full monster tattoo sleeves on both arms, unmatched socks, Vans, and his hair, which the best way to describe it is artistic—and Christian is truly abstract.

Christian always pushed
everyone out of their comfort zone

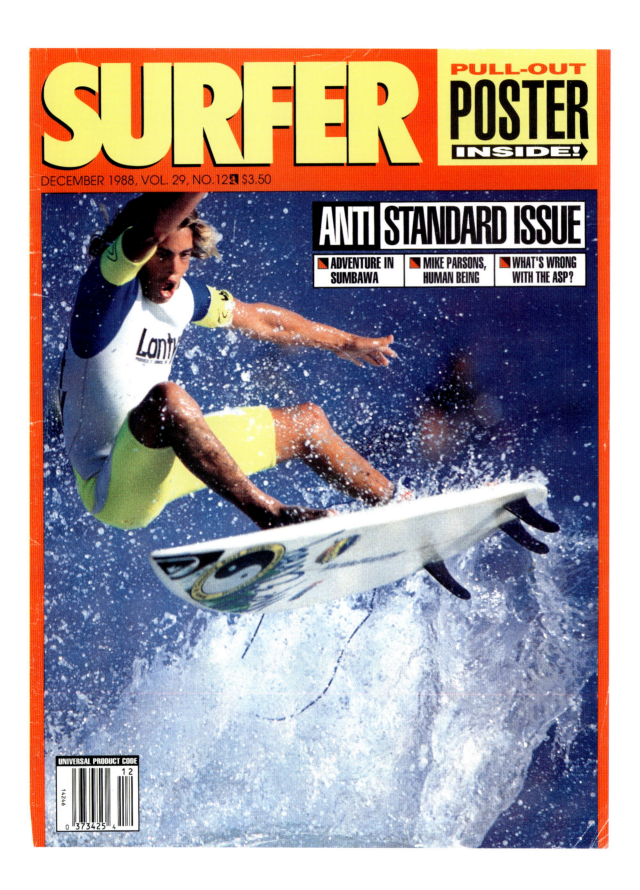

# SURFER

DECEMBER 1988, VOL. 29, NO.12 $3.50

**PULL-OUT POSTER INSIDE!**

## ANTI STANDARD ISSUE

- ADVENTURE IN SUMBAWA
- MIKE PARSONS, HUMAN BEING
- WHAT'S WRONG WITH THE ASP?

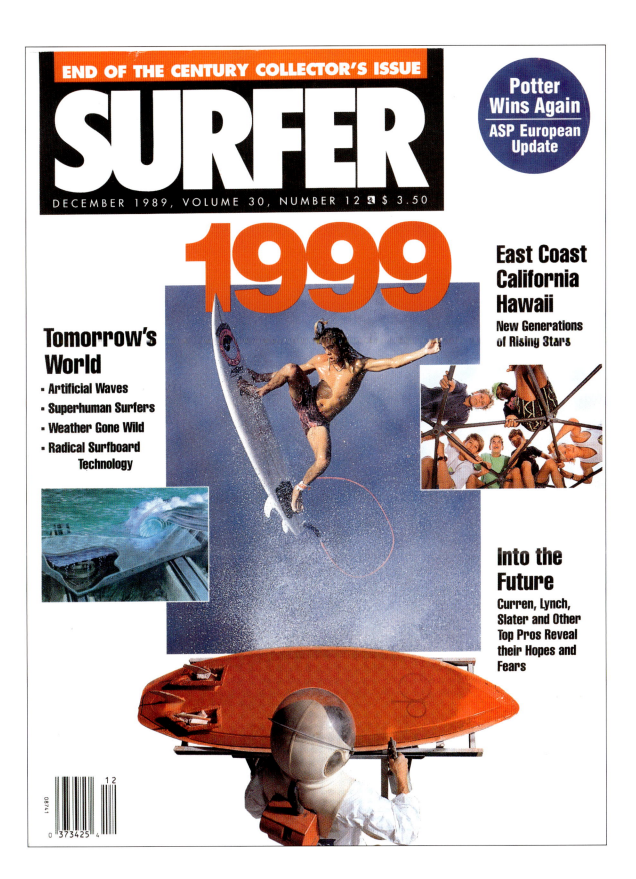

END OF THE CENTURY COLLECTOR'S ISSUE

# SURFER

DECEMBER 1989, VOLUME 30, NUMBER 12 $ 3.50

**Potter Wins Again**
ASP European Update

# 1999

## East Coast California Hawaii
### New Generations of Rising Stars

## Tomorrow's World
- Artificial Waves
- Superhuman Surfers
- Weather Gone Wild
- Radical Surfboard Technology

## Into the Future
Curren, Lynch, Slater and Other Top Pros Reveal their Hopes and Fears

Mute Alley OOP, 1989

First stalefish published,
Surfer Magazine, 1989

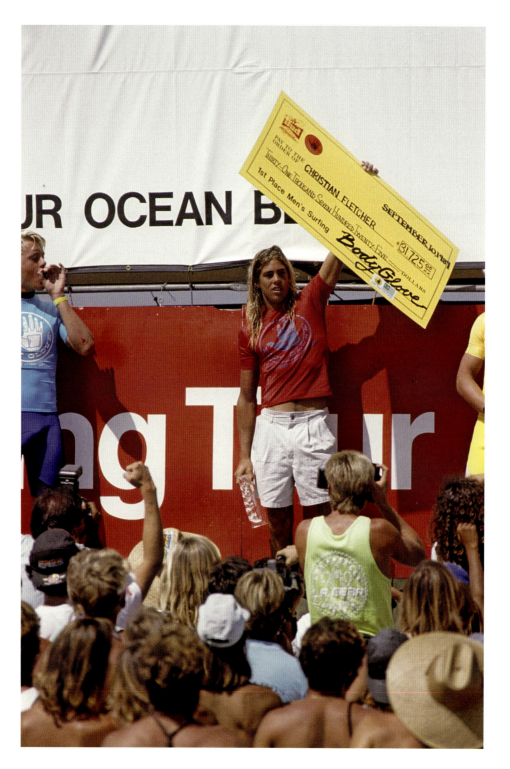

"PSAA Bud Tour at Trestles, 1989. I came from the first round of the trails, then ended up winning the event. I was eighteen years old. It was the largest purse ever in surf history at the time, $31,725.00"
—C.F.

# POST

## PROS TAKE A STAND

As editors of one of the most prestigious surfing magazines in the world, we ask for your help and support.

Today it seems your magazine is running on a large quantity of photos of lesser-known surfers. False images are being created out of second-rate surfers at the expense of high-ranked professionals. We are being hurt by these misrepresentations.

The professional surfers of the world urge the magazines to portray the sport a bit more realistically. Sure, there's room to expose local talent, but not excessively. The readers lose sight of who the world's best really are. What happened to the magazines that read like a Who's Who of the surfing world? When it meant if you were hot, you were published.

The magazines need to expose the best surfers and the rookies moving through the World Tour rankings; the ones who are performing at the highest level. In this way, the readers can identify with the champions.

Take tennis, for example: The top guys are featured on the covers as well as on the inside. If an unknown places well in a tournament he gets credit in the magazines. They use a system of coverage based on performance.

We professionals would like to see more of this in your magazine. It's quite unfair to dedicate yourself to the sport, train hard and travel around the world, only to pick up a magazine and see a guy who spent his summer at Trestles on the cover and centerspread.

Please send the photographers on the Tour with us. They could take photo trips with the best, not the unknowns. Market value of a pro is based on the amount of coverage a surfer gets in the magazines. For the majority, competing for photos with the unknowns while on the Tour is next-to-impossible. We all need and value the exposure in your magazine, and look forward to your support.

Jeff Booth, and the following surfers:
Barton Lynch, Graham Wilson, Damien Hardman, Hans Hedemann, Tom Carroll, Mitch Thorson, Gary Elkerton, Richard Marsh, Martin Potter, Nicky Wood, Glen Winton, Ted Robinson, Dave MacAulay, Greg Anderson, Rob Bain, John Shimooka, Brad Gerlach, Vetea David, Marty Thomas, Michael Barry, Shaun Tomson, Rod Kerr, Sunny Garcia, Mike Rommelse, Todd Holland, Mike Parsons

*While everyone here at SURFER has a great deal of respect for the valiant surfers on the ASP Tour, it is our readers who really dictate the content of the magazine, and our duty is to give the people what they want. So, readers, both we and the ASP surfers above await your verdict on this matter—write in and let us know what you think. Meanwhile, the guy "who spent his summer at Trestles," Christian Fletcher, gives his views on page 138 in this issue...Ed.*

## RECOMMENDED READING

First off, I'd like to say the editorial direction you've been taking of late is really refreshing. It's great to see literary content in your magazine again. In fact, the whole artistic facet of surfing got lost in the flash and glitz for a while, but it never went away.

It was interesting to note in Post (December issue) that Nat Young's eloquent and precise observations of our present situation didn't draw any noteworthy response, while the earlier Dora article (as always) created a mild maelstrom of reactions. If anyone out there didn't read Nat's article, try it! If you did, read it again. I did.

Steve Merrill,
The Surfrider Foundation

## WAIKIKI NOSTALGIA

Reno's article in the September issue brought back great memories. Nineteen-sixty-five was a very special year on the South Shore of Oahu. For those of you who weren't around then, about a third of Waikiki (the "Jungle") consisted of wooden cottages and bungalows renting for $40-$90 per month. Dinner at the Blue Ocean, overlooking the beach, cost $1.25. Life took place in slow motion, and every day was an adventure. Especially when you woke up in the morning with the ground shaking like an earthquake, and the air full of thunder and salt spray. You'd take a walk down to the beach and it was a sea of confusion, with water going in every direction.

About a mile offshore was where it was happening on zero-break days. Straight vertical walls of water as far as you could see in either direction. The channel Reno talked about sectioned this seemingly-endless wave so that it shouldered off into deep water, making the very biggest waves surprisingly easy to ride. Getting out there was the hard part. In addition to the guys Reno mentioned, other regulars were Fred Hem-

*I loved making paintings. of Christian '91*

Christian GOin' oFf!

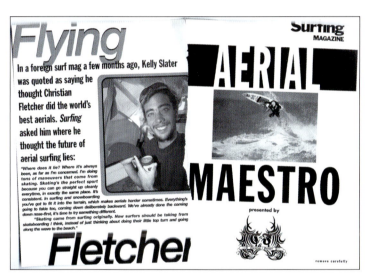

## Flying

Surfing MAGAZINE

# AERIAL
# MAESTRO

In a foreign surf mag a few months ago, Kelly Slater was quoted as saying he thought Christian Fletcher did the world's best aerials. *Surfing* asked him where he thought the future of aerial surfing lies:

"Where does it lie? Where it's always been, as far as I'm concerned. I'm doing tons of maneuvers that come from skating. Skating's the perfect sport because you can go straight up cleanly everytime, in exactly the same place. It's consistent. In surfing and snowboarding you've got to fit it into the terrain, which makes aerials harder sometimes. Everything's going to fakie too, coming down deliberately backward. We've already done the coming down nose-first, it's time to try something different.

"Skating came from surfing originally. Now surfers should be taking from skateboarding I think, instead of just thinking about doing their little top turn and going along the wave to the beach."

## Fletcher

presented by

remove carefully

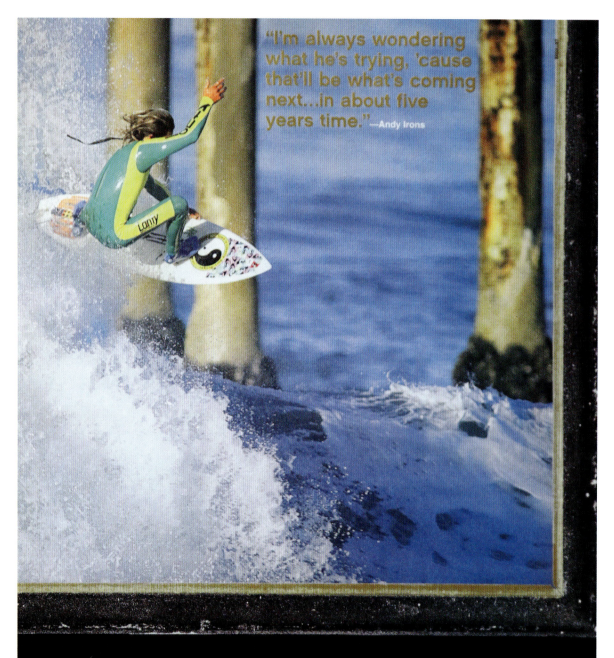

"I'm always wondering what he's trying, 'cause that'll be what's coming next...in about five years time." —Andy Irons

"I wanna go off; I wanna fly the biggest airs I can do. I wanna find my limits, because I don't think I have any." In 1991, an era when a lot of guys on tour surfed like corroding robots, it was the coolest thing anybody had heard in a long time. Christian surfed how we all dreamt it could be. In '89, his part in *Wave Warriors 4* was almost too much to handle. To an obscure speed metal song by the band *Gadnium*, he opened our eyes blasting air combos, stalefish grabs, flowing through tubes and hip-pie-style hair whips out of meaty layback snaps. We were ready to burn our contest jerseys for good (unless, like Christian, we could pull down 30 G's clicking ollies in the Lowers comp). People loved him and people hated him. His stance was wide, his style raw — we thought he was sponsored by the heavy metal radio station *KNAC*. With support of his pop, Astrodeck inventor Herbie Fletcher, there were new videos of him coming out all the time. There was *Supernatural, Tweak Freaks, Savage Beast* and we had to have them all. How else were we to know how to do a frontside boardslide or a mute alley-oop? And not in some kook, sports coach kinda way, but just 'cause you wanted to "surf how you feel." How else were we to enjoy each session, even when falling trying new stuff, even when dudes told us we sucked? Christian's one of the greatest ever, because he showed us how.

*Andy + Bruce, completely got Christian*

# CODE RED

Nathan was always a big wave rider. When he was five years old, he used to paddle out to the reef, about 350 yards off the beach in front of my parents' house where the biggest waves were breaking, to catch a perfect bomb, completely fearless. He wore a hot pink wetsuit so we could spot him in the lineup in case of emergency. He had a keen sense of adventure tempered by a large dose of cautiousness that gave him an interesting sense of balance.

Five years younger than Christian, Nathan always wanted to keep up and hang out with Christian and all his friends, and certainly didn't want to get left home with me when Herb was packing up for some adventure. But unlike Christian, he was even-tempered and easy to get along with. So he got to go, and it pushed him to keep up. Whether being towed into waves behind Herb's Jet Ski or riding Wiamea Bay at eleven years old, he pursued his goals thoughtfully, respectful of the challenge and the degree of danger.

He had been good student, but by seventh grade we decided on home schooling, thinking with all the travel we did it would be easier for him keep up. It was challenge, but Nathan was dreamer and most schools aren't very well-equipped to cultivate skills that can't be measured by SAT scores. He spent hours in my painting studio with me, doing his homework. He had a tutor, a guitar teacher, and was able to surf and skate every day. Unlike Christian, who never liked being alone, homeschooling was a good fit for Nathan and I'm grateful we made the right choice.

At eighteen, Nathan all but gave up surfing, in part because of the shadow that had been cast over the family from the negative publicity about Christian. He put on a helmet, enjoying the anonymity, and pushed headlong into motocross, taking his surf/skate maneuvers in a whole new direction. With a couple of friends, he helped to pioneer the aerial acrobatics that are enjoyed in the sport today. A few injuries later, that siren song that all men of the sea have spoken and written about at length, beckoned again.

Always a believer in the magic of nature, after he scored two IOs in a heat during an event at Teahupoo, Tahiti, he knew he was on the right path. Though absent for a while and not on the tour, he was an asset, and sponsorship was available. He had the maturity and experience to take advantage of the opportunity and bring something more to the bargaining table. With memories of how important films like *Wave Warriors* were, he started working with his sponsors on film projects, which helped chronicle his travels with his team mates and became in-store advertising vehicles. By this time all major companies had their own cameramen and film crews to capture surfing adventure/lifestyle, and Nathan was completely at home in this environment, having been doing it since grammar school.

All the traveling soon took its toll. The industry itself was going through major changes as the 2008 economic downturn had companies firing en masse, trying to stop the bleeding before it could right itself, and Nathan found himself without a clothing sponsor, usually the main source of income for surfer, or skater. Vans had been his shoe sponsor for years, and they felt a head-to-toe program with Nathan was a perfect fit. Interestingly, they had been buying fabric from my

Dad at Hoffman's since the two Van Doren brothers started their company in 1966. Nathan once again put together his travel itinerary to follow the waves.

In November 2010, he and Sion Milosky, a friend and truly inspired big-wave rider, traveled to Mavericks for a huge swell. After they got out of the water and were drying off in the parking lot, they were told of Andy Iron's death. They immediately headed to Kauai to be there for Andy's brother, Bruce. The trip was surreal, and not long after the service Nathan recounts a story of seeing a white owl, which in hindsight he felt sure was an omen. Four months after Andy's death, Sion drowned at Mavericks, after what some said was a two-wave hold-down. Nathan searched frantically for his friend, and he finally recovered his lifeless body and brought him to shore.

These events changed Nathan. For months he was depressed and inconsolable. Eventually, little bits of the magic of life started to seep back in, and he could cherish the gift of friendship that these two men had given him. He rededicated himself to living a life that would honor their memories.

In August 2011, he was on a trip to Tahiti with Adela, future wife. They were just cruising, spending time together, and he had no thoughts about surfing. He was completely unprepared, which has always been an aspect of his casual, laid-back attitude. I can't remember how many times he's lost his wallet, keys, passport, or phone; he's just like Herb in that sense—it drives me crazy, and doesn't seem to bother them at all. On this particular day, when he got to the end of the road around 8AM and could finally see the break, he knew it was the biggest swell he had ever seen there. He spotted Kelly Slater and pulled over to

speak with him, asking what he thought was going to happen. Kelly replied, "I think someone's going to catch the biggest wave ever." Makua Rothman came over and asked Nathan "Hey, if I can borrow a Ski, I'll whip you in." No warm up, a borrowed Ski, the National Weather Service had issued a CodeRED alert . . . Nathan was in. The wave he caught at Teahupoo that day would be viewed around the world as one of the greatest rides in surf history.

The awards were nice, the press couldn't get enough, the photos and videos were horrifyingly captivating. I believe it also made Nathan feel he was no longer just the grandson, son, or brother of surf legends—he had carved out a place for himself as an equal.  With the birth of his son Lazer Zappa in November 2013 and his second son, Jetson Epic in December 2015, the cycle of life began yet again, and the boys show all the signs of being another generation of thrill seekers.

Nathan was always *always* cautiously fearless

VOLUME THREE, NUMBER TWO                                    QUARTERLY    $12 95

# THE
# SURFER'S
# JOURNAL

**PERSPECTIVE**
Endless Summer Stories by Dana Brown

**TRAVEL**
A Surfer's Guide to Queensland

**HISTORY**
Hot Curl Surfing by Craig Stecyk
Tom Morey's Great Nose Riding Contest

**PHOTOGRAPHY**
Portfolio: The Open Eye of Ted Grambeau

DOUBLE-SIZE ANNIVERSARY POSTER: 40 YEARS, 348 COVERS

# SURFER

NATHAN FLETCHER
EMERGES FROM
THE SHADOWS—PAGE 90.

www.surfermag.com
Display Until November 17, 1998

## THE BIG LIE
### WARNING: THIS MAGAZINE HAS NOTHING TO DO WITH THE WAY YOU SURF

0 74470 01528 4

U.S. $3.99 CANADA $4.59
JANUARY '99 VOL. 40 NO. 1
A PETERSEN PUBLICATION

2ft - 50ft  for Nathan
It was always pure stoke!!!

# FAMILY MEMORIES

## STEVE VAN DOREN

The Van Dorens moved to Southern California in 1964. It was then when our family was first introduced to surfing. We lived in Huntington Beach, where the 1964 Surfing Champion event was held at the famed Huntington Beach Pier. This was where my father, Paul Van Doren, first met surfing icon Duke Kahanamoku with four other top surfers, and custom made a pair of lace-up shoes, later to be called the "Style 44," with surfer Fred Hemmings's Hawaiian shirt.

This was our introduction to surf culture—and it surely didn't stop there. Vans became a company 18 months later, and I met Herbie Fletcher in the '70s at a local tradeshow—Herbie's influence and support of surfing culture was so special, and I knew I wanted to be a part of that. Because of him, we soon sponsored Herbie's son Christian Fletcher in the early '90s, with help from our team manager, Scott Sisamis. Christian had been pushing surfing progression with radical skate-inspired aerial maneuvers. His abilities were unparalleled, like nothing I've ever seen. When the Vans Air Show event began, so did Christian's skateboarding abilities. Scott also watched his brother, Nathan Fletcher, grow into his surfing talent, and asked him to join Vans. Nathan was, and still is, a true pioneer in surf, from two feet to one hundred feet.

At the end of 2001, my daughter Kristy and I met Dibi for the first time at Camp Pendleton. We built a ramp on the base to show support for our Marine troops going off to war, and everyone in the industry joined in. Over the next decade, Dibi became a close friend and introduced me to her father, Walter Hoffman, who owns Hoffman Fabrics. Hoffman Fabrics offers tens of thousands of Hawaiian prints that speak perfectly to the Vans aesthetic. I have been able to connect Vans with Hoffman's timeless prints in several collaborations, not to mention me poaching dozens of my favorite designs to make my own shoes and shirts.

From there, the Van Doren and the Fletcher bond continued to blossom. Vans started sponsoring the Bondi Bowl contest in Sydney, Australia, introducing the next generation of Fletchers to come together once again with the Van Dorens—Greyson Fletcher. He was a purebred natural. Like his forefathers, Greyson's talent helped to support the Vans Park Series, an event held every year in Huntington Beach, returning to that same infamous pier, where it all began.

For decades, my family has been grateful to witness the phenomenal creativity and talent of the Fletcher family. Whether it's during prestigious skate contests around the world, or on the North Shore in Hawaii where the waves are near-perfect all the time, our two families have endured remarkable memories together lasting more than fifty years. It's an honor to call the Fletchers my friends. Thank you, Herbie and Dibi, for raising such as awesome family—Vans has had the privilege to showcase your passion through our brand, and I look forward to the many journeys that await us in the future.

Surfing
through the
eyes of :

NATHAN

VANS "OFF THE WALL"

metaphysical, and the radical with a method all of his own. He found motocross to his liking and dedicated himself to a sport where his family name brought him no special treatment. He created a new group of friends and lived for riding dirt bikes the same way his dad lived to surf Pipeline in the 60s with a half-dozen other guys.

Riding motorcycles and skateboarding were the important things to Nathan. His understanding of the alternative culture in skateboarding was inherent, and he was drawn to it like a moth to a flame. But his rebellion from all things surfing wouldn't last a lifetime. In the summer of 1998, Nathan traveled to a hard-to-pronounce town in Tahiti, camped in a tent, and surfed a spot that at that time had not yet been plastered all over the pages of every surf magazine on Earth.

Nathan's reintroduction to surfing took place at Teahupo'o for the absolute pure fun of getting barreled. That same summer Gotcha sponsored the WQS qualifier at Teahupo'o, and Nathan entered as an alternate. With nothing to lose and no sense of competitive drive to suppress his natural energy, Nathan tied for thirteenth and landed a sponsorship deal with Gotcha.

The deal with Gotcha wasn't handed to him. This wasn't the byproduct of his appearance in the *Wave Warriors* movies produced by his father or because his older brother practically reinvented the aerial. He wasn't awarded these spoils because of his family—on the contrary, he earned them in spite of it.

In hindsight, Nathan's abrupt absence from the surfing world and his subsequent dive into skateboarding, snowboarding, and motocross is one of the major reasons for his progressive style and totally modern approach to surfing. If the Fletchers have been anything to surfing, they have been ahead

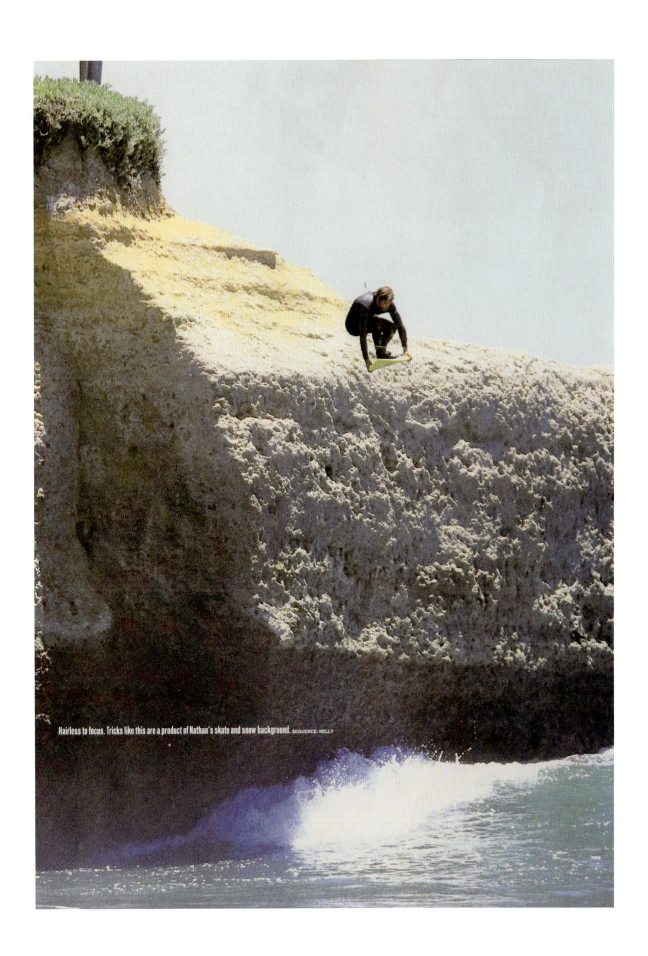

Hairless to focus. Tricks like this are a product of Nathan's skate and snow background. SEQUENCE: NELLY

2007 ROOKIE WORLD CHAMP STEPHANIE GILMORE "I SEE NO REASON TO STOP WITH JUST ONE" PG.63

THE HAWAII ISSUE

SURFING

# SURFING
MAGAZINE

## THE BEST OF
## HAWAII 07/08
### SEARCHING FOR ALOHA ON THE NORTH SHORE

Nathan Fletcher: deep undercover at Off the Wall. PHOTO: DANIEL RUSSO

APRIL 08 VOL 44

A Carbon Neutral Magazine

APRIL 2008 SURFINGMAGAZINE.COM

USA$4.99 CAN$5.99 DISPLAY UNTIL 3.25.08

04

T

0 74470 30280 3

04

A SOURCE INTERLINK MEDIA PUBLICATION

NORTH SHORE IN
BLACK AND WHITE

NEW FOUND
WAVES IN CANADA

The Best Goes On ...

# THE WIZARD

Greyson was born in March 1991. Christian was twenty-one and Greyson's mom, Jennifer, was twenty-three. They had a nice little house in south San Clemente that I helped Christian buy with an investment from me and the prize money he had won from the surf contest at Lower Trestles. It was a nice older three bedroom on a quiet street close to the beach with a huge backyard that would be perfect for a skate ramp. It was a great place for the new family. It was apparent very early on there were serious problems in the relationship, and Jennifer soon moved back home to her parents' house in Anaheim with Greyson.

There are two sides to everything, but it didn't matter; the only thing that mattered was getting to spend time with Greyson, and we did. Herb would drive over the hill on Friday after work and pick him up for the weekend. He was very shy, but this was fun like Herb knows how to have with kids, and Greyson loved it. There were surf trips to Cabo, snowboarding in the backcountry of Utah, and skate trips all over California. Herb taught Jennifer how to take Greyson skating at Vans in Anaheim during the week so he could practice.

When he was eleven years old, Greyson went to France with his dad and uncle Nathan, who were competing in the Quik Cup; a surf/skate/snowboard contest put on by Quicksilver whose slogan in 2002 was "if you can't rock and roll, don't f@#$ing come." The twenty invitees were the most outrageous, hard-partying, go-for-it pros competing for the coveted prize of being known as the best all-around action sports hero and a twenty-five thousand dollar first-place check. They traveled by train, and also along for the ride were the photographers, writers, contest officials, and the hangers-on who are always around to fuel the party atmosphere. Nathan had won the year before and was hoping to do so again. Greyson, a quiet kid by nature who had been skating and snowboarding for years, was physically up to the adventure, but this was no parentally sanctioned after-school event.

I got him a starring role in an HBO series at fifteen when they green lighted my story pitch. The show folded after nine episodes. He had many other offers to pursue more in that arena, but told me that it wasn't a good fit for him; he said he felt safer on the train with the hard-partying action sports devotees then the people in pressed jeans involved in big-budget Hollywood deals. Greyson started to drift a bit after that, but by 18 he was set on moving forward with his skating and decided to stay with his dad for a while. They both came to work at Astrodeck, the family business—what better college education could we offer Greyson than being involved in an action sports business? He thrived in the environment and took off early to surf or skate every afternoon. There were domestic and foreign road trips, and videos and photos started surfacing of his unchoreographed, fast, loose surf style, bowl skating. His style seemed fresh and reminiscent of early skaters at the same time, and many skate legends from the past rallied

their support of him. At first, just like it was with Nathan, Greyson didn't want to get thrown into the "Fletcher" mix. He wanted to earn his own place with his own ability, which is completely understandable. But it is what it is, for better or for worse, there is no separating from the DNA; there is only excelling if you want to stand your own ground. And excel Greyson did, for sure!

Greyson got a board and clothing sponsorship to help with a travel budget and started life on the road. He went all over Europe, Australia, and the States, and his reputation as a skate—and more important to me as a fantastic guy—started to grow. Everywhere he went he was greeted by people who knew his dad, his uncle, even his grandpa. At first these intrusions were irritating to him, but now, as he told me a couple of weeks ago, it makes him feel at home everywhere he goes—people welcome him as an old friend of their family, not as an interloper into their "locals only" vibe. The great contemporary Brazilian skaters immediately took Greyson under their wing and he has matured immensely as a competitive skater with their help. Skating, like surfing is an individual sport, but the young Brazilian skaters all practice together, travel together, and push each other to be their best. Their acceptance of Greyson into the tribe has helped him mature and develop a sense of being part of a team, and they love being part of team Fletcher.

Hindsight, supposedly 20/20: do I think that train ride was a good idea? YES. I had great faith in Christian and Nathan that they would take care of Greyson, as they had been taken care of by Herb on all their own wild adventures. Greyson, like each one of us, has had an interesting path on the road to self-discovery. It seems incredible to think that young timid kid is the guy who spent the last

year traveling the world competing in some of the greatest pool riding events on the professional circuit, then flew to Bali to surf the waves of his life and solidify his place as one of the stars in a very select group of action sports heroes. I asked him recently about that long-ago train ride. We laughed and he said "I think it was like looking through a kaleidoscope into my future, crazy huh?"

Quick Cups, France, 2002

Christian y Greyson livin the life...
Spain, 2016

North Shore, Oahu, 2018
-Good Luck-

# ACKNOWLEDGMENTS

I would like to express my sincere thanks to all the photographers who have graciously contributed their work to make this book possible. In the fast on-line media of today we are bombarded by images, and few linger long enough to become symbols of an era. Going through the thousands of photos preparing this book, it was difficult to pick which ones would best portray the sense and feel of my family over the last seven decades, as they were all equally extraordinary.

I sincerely hope the readers will take the time to look up the photographers included in this book to enjoy their work more fully.

First published in the United States of America in 2019 by

Rizzoli International Publications, Inc.

300 Park Avenue South

New York, NY 10010

www.rizzoliusa.com

Texts: Mike Diamond; Dibi Fletcher; Gerry Lopez; Barry MacGee; Julian Schnabel; Kelly Slater; C. R. Stecyk III; Robert Trujillo; Steve Van Doren; Bruce Weber

Publisher: Charles Miers

Editor: Jessica Fuller

Production Manager: Alyn Evans

Managing Editor: Lynn Scrabis

Agency: Gio Chiappetta

Creative Direction: Jared Freedman

Design Direction: Gio Chiappetta

Art Direction: Show Yoda

Printed in China

2019 2020 2021 2022 / 10 9 8 7 6 5 4 3 2 1

ISBN: 978-0-8478-6641-0

Library of Congress Control Number: 2019940537

Visit us online:

Facebook.com/RizzoliNewYork

Twitter: @Rizzoli_Books

Instagram.com/RizzoliBooks

Pinterest.com/RizzoliBooks

Youtube.com/user/RizzoliNY

Issuu.com/Rizzoli

**CITIZENS *of* HUMANITY**